SORTED BOOKS

SORTED BOOKS

NINA KATCHADOURIAN

Introduction by Brian Dillon

CHRONICLE BOOKS
SAN FRANCISCO

OPEN STACKS
BRIAN DILLON

"I am unpacking my library. Yes I am." Thus the famously odd beginning to Walter Benjamin's 1931 essay "Unpacking My Library." Odd, that is, because, even allowing for peculiarities in the original German or the English translation (which I am unable to judge) and bearing in mind the intimate scene that Benjamin wishes to capture at the outset as he asks us to picture his books strewn about him, the line "Yes I am" has struck many readers as awkward and redundant. What exactly is its tone? Playful? Relieved? Triumphant? Pompous? (I always read it as if punctuated otherwise: "Yes I am!") In light of Nina Katchadourian's "Sorted Books"—a project that for twenty years has seen the artist arranging armfuls of books and their titles to poetic and deadpan comic effect—I have begun to think that he might have meant it a little defensively. *I* am unpacking my books, he seems to say; they are not unpacking, or shelving, themselves. As if that is the kind of thing we could expect libraries to do when we are not looking.

Perhaps this interpretation seems more fanciful than Benjamin's little sentence allows. Consider, however, the word that Katchadourian uses to describe her gatherings of three, four, or five (sometimes, but rarely, fewer or more) volumes. She calls them *clusters*, and the word has a plausibly organic implication: it is as though the books have convened of their own accord like plants or insects—following secret or, in the case of the more explicitly comic or narrative groupings, not-so-secret attractions. But a "cluster" might equally be an astronomical phenomenon, like a constellation: a design composed or conjured out of vastly distant points in space, seen as such only from a single vantage. Or it might be a phonetic aggregation of consonant or vowel sounds, flung into intimacy by speech though they belong to different words. *Webster's Third New International Dictionary* gives us the consonantly crunchy phrase "winch sprocket" by way of example: read it aloud and the cluster "nchspr" suddenly seems an unlikely thing to have

said. A cluster, in other words, yokes together discrete elements in an order that is at once natural and estranging.

Isn't this to some degree how we organize and use our libraries? Of course, there are fastidious individuals who line up their books by strict alphabetical order—though even in such cases subjective choices must be made, such as whether to order by author name or by title, the latter much less likely. And at the other extreme—if that is indeed what it is—the likes of art historian Aby Warburg, who notoriously structured his library by affinity or correspondence: a scholarly version of the prevalent belief on the part of sloppier bibliophiles that they themselves constitute the ordering principle and can lay hands on any book at a moment's notice. (This is almost always a consoling fantasy. Though as Georges Perec puts it in his "Brief Notes on the Art and Manner of Arranging One's Books" [1978], one can always trawl the whole library: "An unsorted book collection is not a serious matter in itself. It is a problem of the same order as 'Where did I put my sock?'") Most libraries, whether seemingly disordered or tidy and well cataloged, actually oscillate between the poles of order and disorder, and in day-to-day use even the most rigorously shelved collection is at the same time a labyrinth of more-or-less random passages between unrelated books that somehow go together by virtue of having sat near or opposite each other for years.

"Sorted Books" is many things at the same time: a series of sculptures, or photographs, or site-specific installations; a collection of short stories, or poems, or jokes; a work in which the "found object" is subject alike to chance and the most painstaking choices; a delicate conceptual game with the horizontal and the vertical. But it is first of all an act of reading. We have to picture the artist at large between the bookshelves, scanning the spines for likely, or unlikely, meetings among their titles. Katchadourian says that in most cases she needs to handle the books themselves, trying out possible alignments, leaving small

piles behind her as she goes, like a careless or impatient student in search of the right dissertation material. (The first occasion on which she altered her intimate and vagrant method was while on a residency at the International Artists Studio Program in Stockholm in 2004; working with the fragile books in the personal library of August Strindberg, she was forced instead to write their titles on notecards, composing her own partial and highly subjective catalog.) It is hard to know how to describe this reading process. Perhaps it is facile. (I mean "practiced and easy" rather than "crass," but Katchadourian surely flirts with that too: judging every book by its cover.) Or actually exacting, penetrative, acute: she sees things on the surface that even the most critical reader could not glean from the texts inside. She becomes a hunter-gatherer among the stacks: she seems to be grazing, but in a moment she will pounce.

It's crucial, I think, this sense of the artist moving on the surface but at the same time spearing or pinning her prey, preparing it for a new life in an alternative, but parallel, collection. This is, after all, what reading consists of anyway. In his 1964 essay "The Book as Object," Michel Butor notes that the chief advantage of the printed book over prior forms such as the scroll—and indeed over then novel technologies such as the tape recorder—is the way it allows us to scan horizontally between pages and vertically through the text, varying our levels of attention until we light on the portion of print that we are after. (And also, of course, allowing us to note and record our place in the text with far greater ease.) We read now—or perhaps we had better say half a century later that we read until recently: a question to which I'll return—in three dimensions: each page is a portal, and the portals multiply like parallel arcades.

One of Katchadourian's most elegant tricks in "Sorted Books" is to have corralled far-flung volumes and their titles, which we may imagine as sparsely arrayed locations on a map

or bright points in a star chart, into the most laconic of textual forms: the list, just one thing after another. We might recall with Butor "the enormous importance of enumeration in classical literature, whether in the Bible, Homer, Greek tragedy, Rabelais, Victor Hugo, or modern poetry." But the point is not exactly to invoke the venerable literary history, or the more recent conceptual heritage, of the list as such—let's just note for now that the artist is no doubt aware of that history and of the structural implications of flattening (or should the term better be *extruding*?) a library into such narrow verbal confines. Instead, consider the sly poetics of the lists themselves. At times they are "pure" lists, paratactic inventories of distinct moments, montage sequences. Quite in accord with Henri Bergson's contention that laughter results when a human being acts like a machine, their comedy is a question of repetition with difference or (funnier) no difference, as in the following from "Composition" (1993):

Repeat After Me
Are You Confused?
Are You Confused?

and

Procrastination
I'll Quit Tomorrow
I'll Quit Tomorrow.

For sure, such clusters also imply certain narratives, and much of the humor in "Sorted Books" comes from the way Katchadourian broaches entire epics, romances, and (more usually) tragedies with the slimmest of verbal resources. (It's partly an old literary game. Think of Ernest Hemingway's stab at a very short story: "For sale: baby shoes, never worn.") The stories in question often seem keyed to the age of the books

themselves, not just in terms of the books' subject matter but also the tone of their titles, their syntax, and their style. For example, the clusters in "Once Upon a Time in Delaware/ In Quest of the Perfect Book" (2012), composed of popular or sentimental fiction, children's books, and improving tomes from the late nineteenth and early twentieth centuries, have about them a kind of blackly comic morality, couched in the language of that time: *Captain Courtesy/An Amiable Charlatan/At Heart a Rake; If Youth But Knew/The Old Knowledge/ At the Time Appointed.* Or a vignette from the late-Victorian encounter between spiritualism and technology: *Phantom Wires/The Moving Finger/The Message.* And the same is true of the first clusters Katchadourian made, in 1993, which wryly deploy the nostrums and assumptions of the nineties' self-help boom, as in *Romeo and Juliet/They Rose Above It/ Codependent No More* and this veritable epic of faux-spiritual self-empowerment: *Relax/When I Relax I Feel Guilty/When*

I Say No, I Feel Guilty/God Always Says Yes!/Don't Say Yes When You Want to Say No.

At times, the books come together to form whole sentences—*Somewhere in France/The Anglomaniacs/Meet the Germans*—or fragments of sentences: *The Outcasts/Breaking into Society/With Edged Tools.* They may turn sententious and sternly imperative—*Hope and Have/The Life that Counts*—or suggest dialogues and encounters that have the stilted tone of a language lesson—*I Am a Conductor/And Do You Also Play the Violin?*—or the makings of a TV comedy sketch from half a century ago: *Speaking of Pianists . . ./Am I Too Loud?/Beethoven Lives Upstairs.* As the books multiply, the syntactical relations between their titles become less secure, so that something like the following seems like an exercise in daringly pushing the logic of the project as far as it will go: *All You Need to Know About the Music Business/Bobos in Paradise/Entanglement/Discord/The Tower of Babel/Music at Court/Great Operatic Disasters.*

One could pursue a rigorous typology of Katchadourian's verbal clusters, their style, and their genre, but you would risk killing off their comedy and their peculiarity, which depend more on a certain laconic tone than on strict decisions about their coherence or flow. And reading "Sorted Books" as a solely textual project is in any case to ignore where a good deal of the work's humor and resonance comes from—what I suppose we have to call the materiality of the books—though the general category of "materiality" always risks bracketing out the actual material of this or that concrete example. In fact, before even considering the books as objects, we have to acknowledge that the whole project depends on our willingness to extract the books' titles from the other fragments of text on their spines and covers—subtitles, authors' names, blurbs, and publishers' names—and from any illustrations or printed motifs. The artist plays very expertly with this last piece when she places in a row a copy of John Ruskin's *Queen of the Air*, Richard Harding Davis's *Her First Appearance*, and a book whose title we cannot see but whose front cover shows a small gilt hand at the bottom right pointing upward to a strange gilt woman who is riding a sort of sea horse. Reading, as Butor points out, is usually a matter of choosing a certain stratum or thread of text to focus on: the printed page is surrounded by epitextual artifacts such as page numbers, running titles, footnotes, and so on.

All of that surrounding textual matter sometimes flickers back into view once we have grasped the main text and its poetic, narrative, or humorous import. We notice, for example, that in those earliest clusters from 1993, the lettering on the books' spines reads from bottom to top, in the continental European manner, rather than top to bottom, as is usual with Anglophone publishers—it may take us some time to register that the books are actually upside down, so that publishers' logos are at the top of the spine, inverted. Such details are reminders of the artist's handling, as are the "blank" books that

have been shelved with spines facing inward and page edges out. Perec writes that it is "unusual, proscribed and nearly always considered shocking to have only the edge of a book on show;" in "Sorted Books," or at least in Katchadourian's photographs of shelved books, the implication is that most or all of the surrounding library has been arranged in this way, rendered anonymous and unmeaning save for these enigmatic messages it turns to the world. There are distinctions to be made, too, between these upright, if inverted, volumes, the stacks that turn titles into lists or verse, and the "faceouts" (as booksellers say) that appear elsewhere, making of the books a sort of frieze.

All of these, one might say, are reminders that books are objects designed to be handled: to sit happily between the thumb and forefinger of a standing rail commuter, to be hefted onto the bedclothes in the case of a hardback, abandoned on the beach face down with a split spine, or, at the farthest scholarly extreme, supported half-open in a cut-foam cradle and paged through slowly with tweezers in a library's rare-books room. Katchadourian's project more-or-less accurately parallels the swiftest acceleration of reading on screen instead of the page: first on the Internet, latterly in (and the prepositional difference is probably important) e-books. You could read "Sorted Books" now in ways that accord with current anxieties about the possible end of the book and therefore of its material particularity, the codes and gestures and sensations that attend it. But it is hard, actually, to find much that is nostalgic or catastrophist about these images and arrangements; they are both too canny and too delighted in the specificity of their source material to mourn its passing or fetishize it in bibliophile fashion. This seems more a body of work about paying attention in the present than fretting about the past or future of the printed codex. As Katchadourian has it in a minimal (just two books) cluster from 1996: *What Is Art?/Close Observation.*

TWENTY YEARS OF SORTING BOOKS
NINA KATCHADOURIAN

The "Sorted Books" project came out of an experiment hatched when I was in graduate school at the University of California, San Diego, in the early 1990s. The school's master of fine arts program was established in the early 1970s by a group of artists[1] invested in reconnecting art with life, and this often influenced and infused their students' work similarly. We studied—and were trying to put into practice—an engagement with the everyday, a stance toward art that located it in unlikely places, and ways of working collaboratively. In that spirit, an art major undergraduate, who was friendly with some of the graduate students, invited a group of us to move into her parents' house for a week and make art with what we found. Her parents—who were not art collectors but simply welcoming and curious people—generously agreed to be invaded by the six of us.

The house where we stayed was in a small town called Half Moon Bay, about an hour south of San Francisco on the foggy California coast, so we decided to call the project "The Half Moon Bay Experiment." We spent about a week there, poking around and thinking about what to make. Eventually each of us found different zones in the house that interested us, and in the end we had a small show, which essentially meant running an announcement in the local paper, opening the front door for the afternoon, and having some friends, family, and locals come by.

Quite early in the week, I latched onto the library. Our hosts had married late in life—a second marriage for both—and they had merged their separate book collections when they moved in together. It seemed like they had decided to keep everything, and so they had a lot of books, organized in a casually thematic manner on wooden shelves. I spent a long time looking at the books and getting acquainted with the wide variety of subjects in their library: Shakespeare, self-help, gambling, addiction, health care, history, and investment strategy guides. I suddenly recalled a moment in the university library when, looking for a book, I had turned my head sideways

1 Allan Kaprow, Eleanor and David Antin, and Helen Mayer Harrison and Newton Harrison among them.

as I walked down the stacks and thought how spectacular it would be if all the titles formed an accidental sentence when read one after the other in a long chain. Standing amidst the bookshelves in Half Moon Bay, my next move was simply to make this imaginary accident real. I spent days shifting and arranging books, composing them so that their titles formed short sentences. The exercise was intimate, like a form of portraiture, and it felt important that the books I selected should function as a cross section of the larger collection.

In both methodology and priorities, all subsequent sortings have stayed true to these ground rules. Portraiture is still a guiding principle, whether I am focused on an individual ("BookPace" and "Reference"), a couple ("Composition" and "Sorting Shark"), an institution ("Akron Stacks" and "Special Collections Revisited"), or a nation ("Once Upon a Time in Delaware/In Quest of the Perfect Book"). The project has even included one posthumous sorting ("Sorting Strindberg") in the library of the Swedish author August Strindberg, whose books I was lucky to gain access to while on an artist's residency in Stockholm in 2004. All the contemporary Swedish authors I initially approached declined on grounds of privacy or discomfort with the idea of a stranger looking at their books. Strindberg had no choice, you could say, since permission was granted by the Strindberg Museum, housed in the author's former home. His books reflected his voracious intellectual curiosity; literature was almost outnumbered by books on linguistics, science, religion, the occult, history, and geography. The books were very dusty, often crumbling and sometimes had Strindberg's own handwriting on the makeshift spines. It gave me some comfort that books themselves were not precious objects for Strindberg; when he was living abroad in the 1880s, he famously wrote to his brother Axel with a request for a shipment of books from Sweden, instructing him that if the books were too heavy for shipping, the covers could just be torn off.

Although it's often described as a photography project, "Sorted Books" really has little to do with making pictures until the very last phase. While I'm in the middle of a sorting, it

feels like a writing project combined with a memory exercise. It involves several types of memorization and recall: spatial ("The book I want is on the fifth shelf, left side"); topical ("Now I need that book about crop-destroying insects"); and visual ("It has a green cover, cloth-bound, with diagonal grain, gold detailing in upper right"). The process relies on maintaining a very associative, open-ended mental stance; the more book titles you can keep floating in your head at once, the more they bump into each other in fruitful ways. More than anything else, the process feels like songwriting: turning words over and over again to figure out where they fit, not only in terms of their content but also in terms of their rhythmic and sonic qualities. Sometimes, when a cluster has worked out especially well, I experience a curious feeling of detachment from the result: it feels like the grouping simply happened.

I am always paying attention to the physical qualities of the books, and I try to work with their particular attributes as much as possible. The size of a book carries temperament and tonality, as does the way the text sits on the spine. A heavy volume with large text on the spine, for example, might be exuberant, urgent, pushy; a small typeface might communicate a voice that's exacting, shy, insecure, or furtive. Several sortings have resulted in the exhibition of actual book clusters, sometimes even presented as sculptures. At the Athenaeum Music & Arts Library in La Jolla, California, for example, I constructed seesaws where a book stack placed on one end counterbalanced a stack on the other, and the weighted relationship added an additional layer of meaning. But I had underestimated the allure of the books themselves; at the opening, visitors enthusiastically picked up books they recognized, and the books on the other end of the seesaw catapulted into the hushed library air.

Despite all the hand-wringing over the demise of the book in our electronic age, this involuntary surge of curiosity that often makes us reach for a book has not diminished in the twenty years since the first book sorting in Half Moon Bay, although it now may be motivated by a combination of factors. Perhaps it's in part nostalgia for an object that is growing

scarce. But with so many other forms of reading vying for our attention, maybe the printed book is also becoming more beautiful, more tactile, and more materially compelling, because it will have to be all those things to justify its existence. "Sorted Books" often induces others to try the activity themselves, and plenty of evidence of this exists on the Internet: blogs where people have sorted their own libraries; teachers who have assigned "Sorted Books" as a writing exercise and posted pictures of the results; and a Flickr page, created by a stranger, on which different people have contributed images made by culling their own shelves. I have been invited to judge "Sorted Books" competitions for various libraries. Years ago, I was cc'd on several irate emails from a kind Italian man who wrote to an advertising firm that he felt (and I agreed) had stolen the project wholesale for their website, but mostly I've been happy to see the project pass through the hands of others. Part of what seems to motivate these strangers is their pleasure in handling physical books and discovering that their bookshelves hold a kind of hidden potential that they hadn't thought about before.

Like so much of my other work, "Sorted Books" originates in the act of looking very carefully (often to things around me that are constantly present but overlooked), responding to a specific situation, and working with limited means. I still love the extreme economy of making "Sorted Books": I show up with almost nothing, make an investment of time, commit my full attention, and leave with a number of images. It forces me to be productive within a situation that is bounded. "Sorted Books" is a milestone project for me because it identified and established a way of working and a stance toward art that has continued to be central in my practice. At the time I started "Sorted Books," I would have found it implausible if someone had told me that twenty years after its first manifestation, this casual project, which owed so much to improvisation and spontaneity, would gather enough mass and momentum to become a book itself. I imagine I'll be making "Sorted Books" the rest of my life. While working on this book, I've become very aware that I've never sorted my own books. Maybe that last sorting should be the final chapter.

SORTED BOOKS

COMPOSITION 1993

"Composition," the first of the book sorting projects, took place in a private home in Half Moon Bay, California. The couple living there were both real estate agents in their forties and had been married for about five years—a second marriage for both of them. They had moved into the house with two discrete book collections that they then merged, filling about twenty tall bookcases that occupied the entire middle section of the house. Their collection contained a great deal of literature, self-help, and motivational writing. In a number of instances, I discovered two copies of the same book—a telling coincidence that I tried to make use of whenever possible.

The Story of My Life
Why Me?
Why Me?

THE STORY OF MY LIFE • Arnold Ehret

BENEFICIAL
BOOKS

Frida Waterhouse

WHY ME?

WHY ME?

Garrett Porter & Patricia A. Norris, Ph.D.

STILLPOINT

The Art of Conversation

Parker

Louis
Gittner

0-96054
92.0-X

LISTEN LISTEN LISTEN

Morris

SHAMBHALA

Leonard *ON THE WAY TO THE WEDDING*

MICHIO KUSHI YOUR FACE NEVER LIES AVERY

WOULDA, COULDA, SHOULDA FREEMAN AND DeWOLF

On the Way to the Wedding
Your Face Never Lies
Woulda, Coulda, Shoulda

CARL BERNSTEIN AND BOB WOODWARD

0-446- 79732-4 195

All The President's Men

$1 95

WARNER PAPERBACK LIBRARY

NONFICTION

VANCE RANDOLPH

0-380-44818-1-250

PISSING IN THE SNOW & OTHER OZARK FOLKTALES

BA30

INSPIRATION

BERKLEY

TOM LATOUR JR. AND KEITH MILLER

0-425- 06272-4 295

WITH NO FEAR OF FAILURE

Nineteen Eighty-four ✦ George Orwell

THE END OF SEX

TARCHER
HOUGHTON MIFFLIN COMPANY

What are you doing with the rest of your life?

HARDIN

New World Library

COPING WITH CANDIDA

Sally Rockwell

CT 311

LEONARD

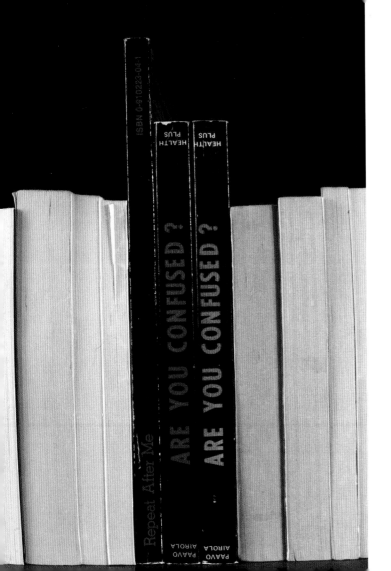

Repeat After Me
Are You Confused?
Are You Confused?

Romeo and Juliet
They Rose Above It
Codependent No More

Romeo and Juliet *Shakespeare*

0-671-50981-0-295

DRAMA

A Fawcett Crest Book

Non fiction

175

0-449-23417-7

THEY ROSE ABOVE IT

Bob Considine

Codependent No More

BEATTIE

HARPER / HAZELDEN PS 4205

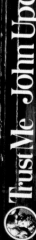

Shakespeare **MACBETH**

Trust Me **John Updike**

HUXLEY YOU ARE NOT THE TARGET

FOR WHOM THE BELL TOLLS

Ernest Hemingway

SCRIBNERS

SL 4

TARCHER
ST MARTIN'S
PRESS

0-445
214968
495

W
115
454

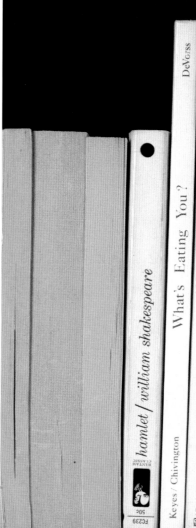

Hamlet
What's Eating You?
Hey. Man! Open Up and Live!

KING LEAR *William Shakespeare*

OLD AGE IS CONTAGIOUS BUT....

If I'm in charge here why is everybody laughing?

EVE BLAKE

CAMPBELL

Relax
When I Relax I Feel Guilty
When I Say No, I Feel Guilty
God Always Says Yes!
Don't Say Yes When You Want to Say No

RELAX edited by JOHN WHITE and JAMES FADIMAN

DELL NF

440-07334-195

WHEN I RELAX I FEEL GUILTY

NON-FICTION $1.95

BANTAM BOOKS

When I say no, I feel guilty

Manuel J. Smith, Ph.D.

553 02768 195

God Always Says Yes!

SUE SIKKING

Don't Say YES When You Want To Say NO

Herbert Fensterheim, Ph.D., and Jean Baer

DELL NF 1.95

0 440 15413 6

REFERENCE 1996

"Reference" took place in a now-defunct New York gallery called Spot. The gallery director, who lived illegally behind the exhibition space, was a photographer and former eye surgeon. His book collection reflected his interest in art history, critical theory, and photography, but it also included many medical reference books—remnants of his past profession. In effect, there were two kinds of books on seeing: the books dealing with vision in the context of art history and criticism, and the books dealing with vision in its most mechanical and literal sense.

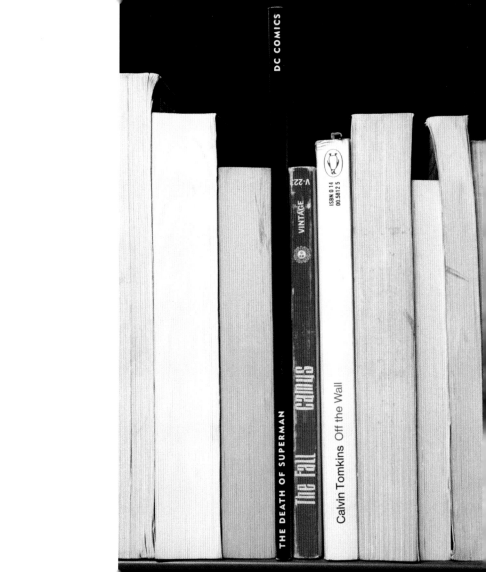

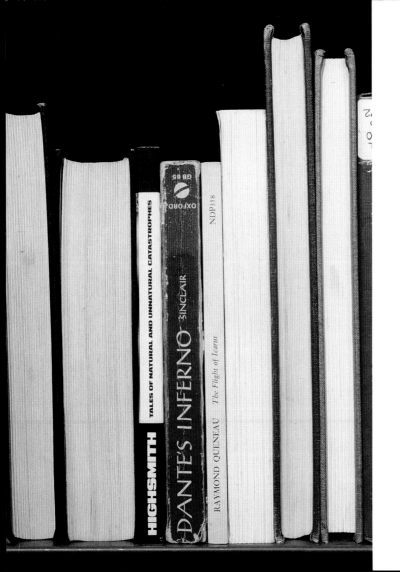

PANTHEON

ITALIAN ITALO
FOLKTALES CALVINO

romeo and juliet / william shakespeare

BANTAM CLASSIC

FC237 50¢

Two Lives and a Dream ✤ MARGUERITE YOURCENAR ✤ FSG

City Lights Books

The Tears of Eros Georges Bataille

NDP315

Death in Midsummer and Other Stories Yukio Mishima

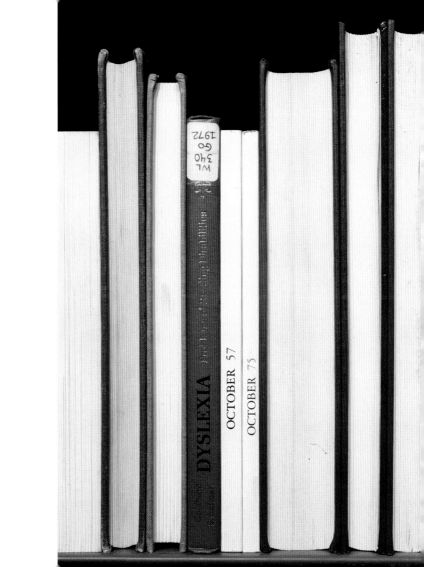

Dyslexia
October 57
October 75

SPECIAL
COLLECTIONS
REVISITED 1996/2008

The book sorting that eventually became "Special Collections Revisited" took place over two different visits to the Athenaeum Arts and Music Library in La Jolla, California: the first was in 1996, when the bulk of the project was done, and the second was in 2008, when I visited the library again and took the opportunity to make a few more clusters.

The library is housed in a beautiful Mission-style building in an upscale shopping district. While working there, I met many charming retirees who frequented the library, some coming to browse and others coming to work as volunteers. The library's atmosphere was quiet, romantic, and contemplative, and its collection focused largely on famous artists and musicians immortalized as classics of the Western cultural past. There was also an unusually large children's book section. When the book clusters were complete, they were exhibited on shelves (with the books stacked horizontally for the first time, since they were easier to read that way) and as seesaw sculptures in the front reading room of the library.

I Am a Conductor
'And Do You Also Play the Violin?'

MUNCH
I am a Conductor

780
.92
M923
B959

OXFORD

CARL F.
FLESCH
'And do you also play the violin?'

787
.2092
F635

STRINGHAM

Second Edition (1959)

LISTENING TO MUSIC CREATIVELY

780
.072
ST84

M. B. Goffstein TWO PIANO TUNERS

YP
786
6552

Doing Art Together by Silberstein-Storfer with Jones

707
S

Simon and Schuster

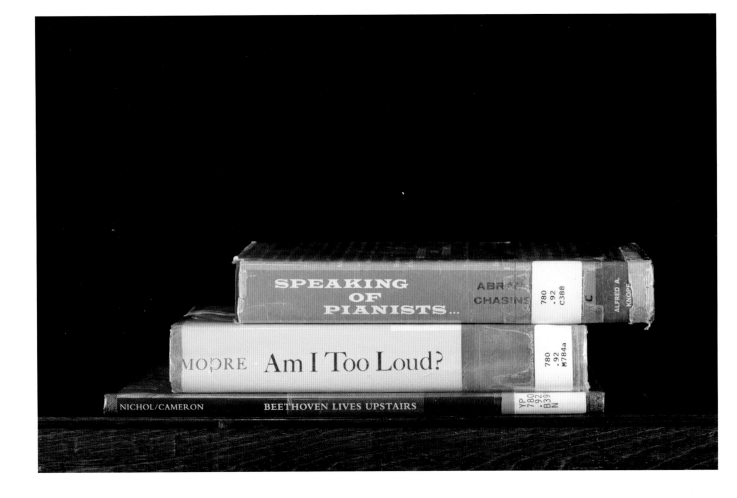

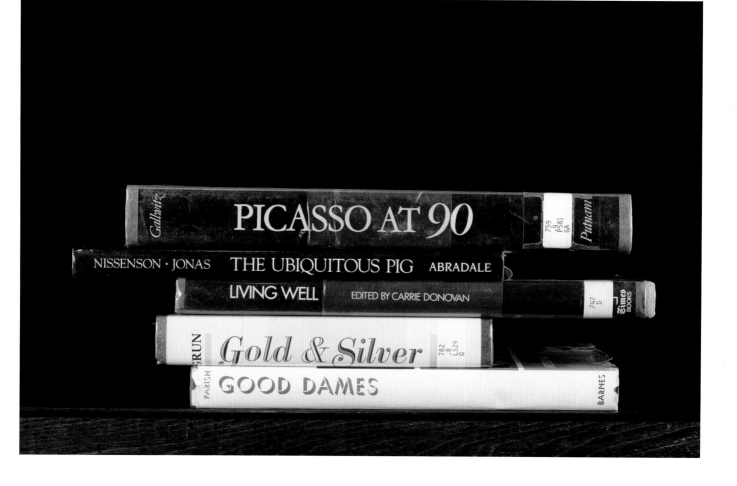

WINTERNITZ — *Leonardo da Vinci as a Musician* — 780 .92 L555 W

FRANK R. WILSON — TONE DEAF AND ALL THUMBS? — 781.5 W — VIKING

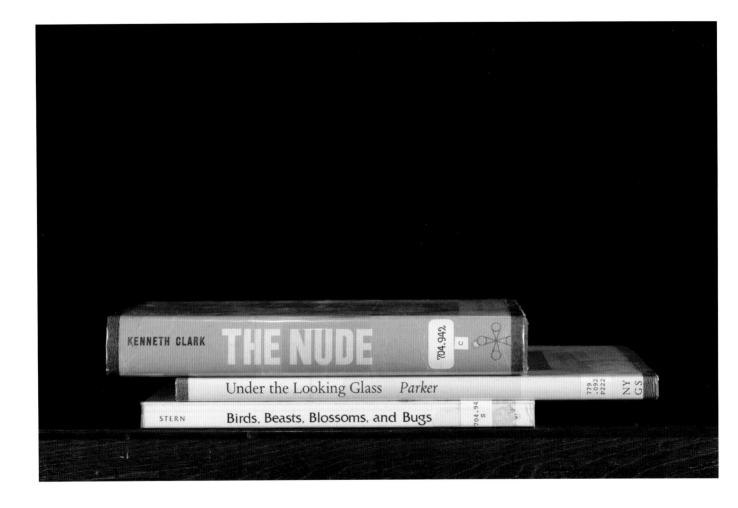

KENNETH CLARK THE NUDE 704.942 C

Under the Looking Glass *Parker* 779 .092 P222 NY G S

STERN Birds, Beasts, Blossoms, and Bugs 704.94 S

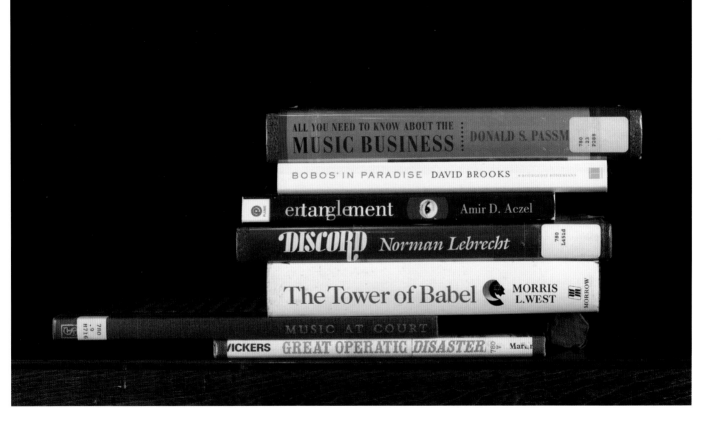

BARBARALEE DIAMONSTEIN

INSIDE NEW YORK'S ART WORLD

All the Right People *Barbara P. Norfleet* 779 .2 N765 NY G S

McClure and Jones STAR QUALITY 791.4 M Barnes

KENNETH CLARK *The Other Half* 709 .2 C5490 HARPER & Row

GO IN AND OUT THE WINDOW YP 7.54 M Henry Holt

Simons/Simons WHY SPIDERS SPIN JYP 398 .21 S155 Silver Press

The Memory of All That Joan Peyser 780 .92 G321 P

PARTCH BITTER MUSIC 780 .92 P259 UNIVERSITY OF ILLINOIS PRESS

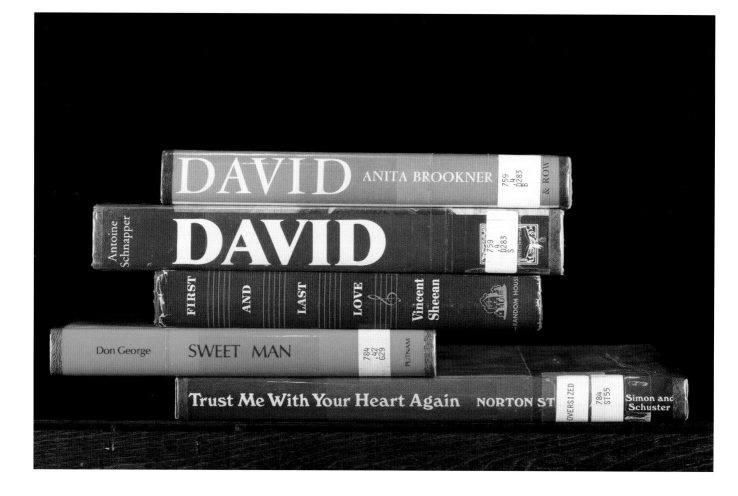

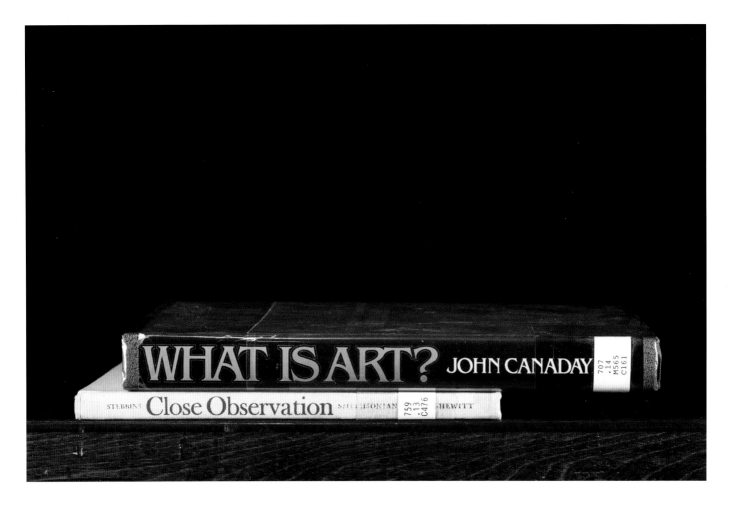

AKRON
STACKS 2001

The Akron Art Museum in Ohio commissioned me to do a book sorting using the holdings of the museum's research library. Their book collection had extensive materials and catalogs from various contemporary art exhibitions, as well as many large-format, hardback monographs. The books from the library did not circulate to the general public, and the library itself was so separate from the main exhibition areas that visitors had no idea the museum included a library at all. One special section held books on the business and fund-raising side of museum administration. Those books felt particularly important to use since these activities are often behind the scenes of the exhibitions. When complete, the book clusters were brought to the gift shop located behind the front desk and integrated into the displays.

Primitive Art
Just Imagine
Picasso
Raised by Wolves

Primitive Art
Douglas Fraser

aming **JUST IMAGINE** **Scribner**

PICASSO

dberg **Raised by Wolves**

The Corcoran Gallery of

ARTIST IN MANHATTAN

YOU HAVE SEEN THEIR FACES

BOILING COFFEE RICHARD NONAS

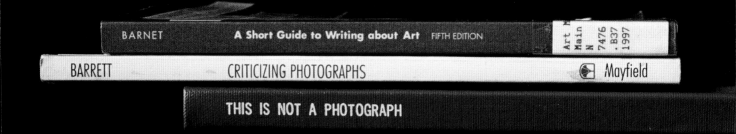

BARNET **A Short Guide to Writing about Art** FIFTH EDITION

BARRETT CRITICIZING PHOTOGRAPHS Mayfield

THIS IS NOT A PHOTOGRAPH

Europe Now
The British Imagination
Blimey!
No Sense of Absolute Corruption

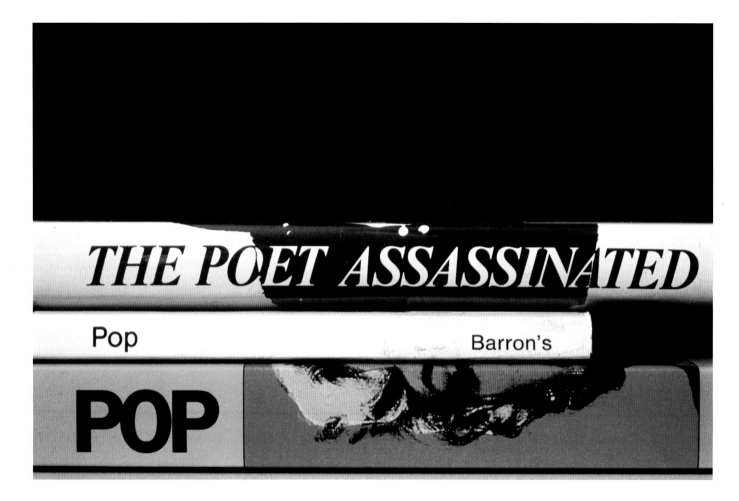

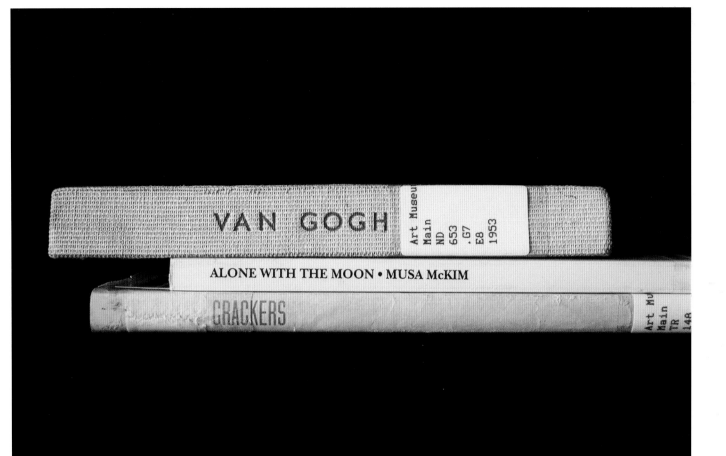

VAN GOGH

ALONE WITH THE MOON • MUSA McKIM

CRACKERS

Conversations with Artists SELDEN RODMA

WHEN TWO OR MORE ARE GATHERED TOGETHER

eyman DREAMS AND SCHEMES

Apertu

ART IN PUBLIC PLACES Beardsley

or Livable Places

WHAT DID I DO?
LARRY RIVERS WITH ARNOLD WEINSTEIN

HARPER **Interventions and Provocations**

ON THIS SITE

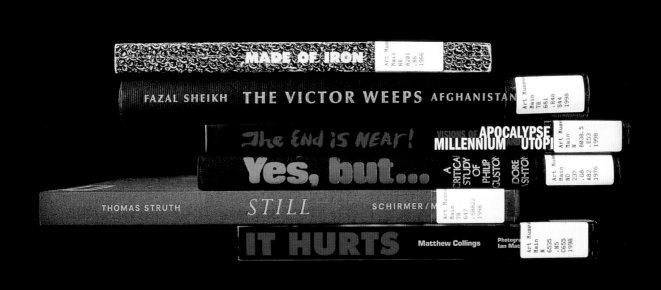

SIXTEEN AMERICANS The Museum of Modern Art, New York

ANDY WARHOL DEATH AND DISASTERS THE MENIL COLLECTION

12 AMERICANS

SORTING SHARK 2001

Shark was a journal on art and poetics based in New York. The two editors, a poet and a painter, published the journal from a home office lined wall-to-wall with books. Cookbooks shared space with books on art history and literary theory. Following an invitation from the editors, I did a book sorting project for *Shark*. The most intriguing part of the library was the extensive collection of contemporary poetry, of which many books had particularly unusual titles. Grammatically, many of these titles were quite unorthodox, consisting of, for example, isolated adverbs or sentence fragments.

Stein **How to Write** Dover 0-486-23144-5

VERY BAD POETRY Edited by Kathryn Petras and Ross Petras

Joseph Torra **KEEP WATCHING THE SKY** ZOLAND BOOKS

BEI DAO UNLOCK NDP901

THE ORIGIN OF THE WORLD • Lewis Warsh

marijuana soft drink.　　Buck Downs　　EDGE

Octopus
and Squid

by Jacques-Yves
Cousteau
and Philippe Diolé

Bernadette Mayer　　ANOTHER SMASHED PINECONE　　United Artists Books

WORTHINGTON　THE CUISINE OF CALIFORNIA　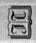 TARCHER/PERIGEE

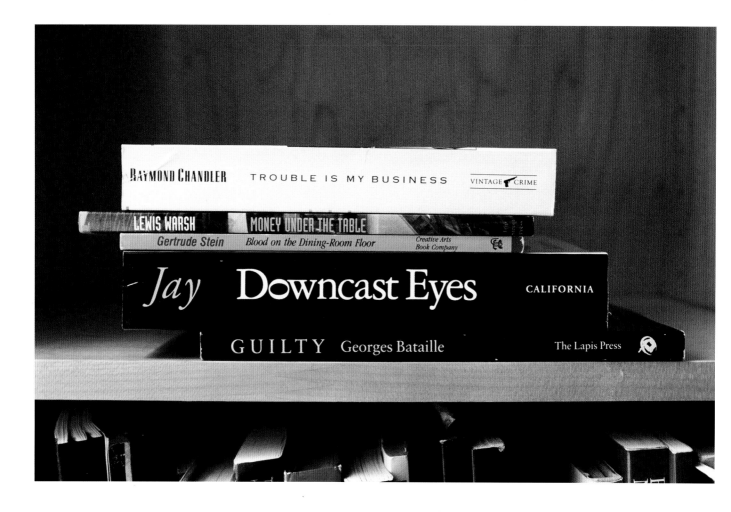

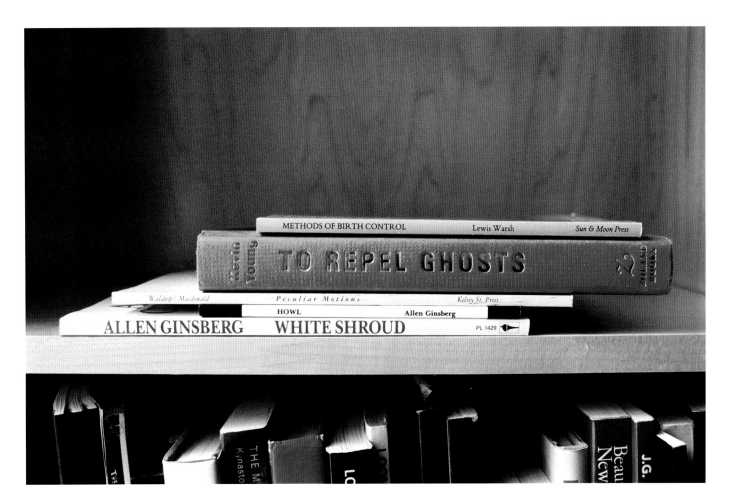

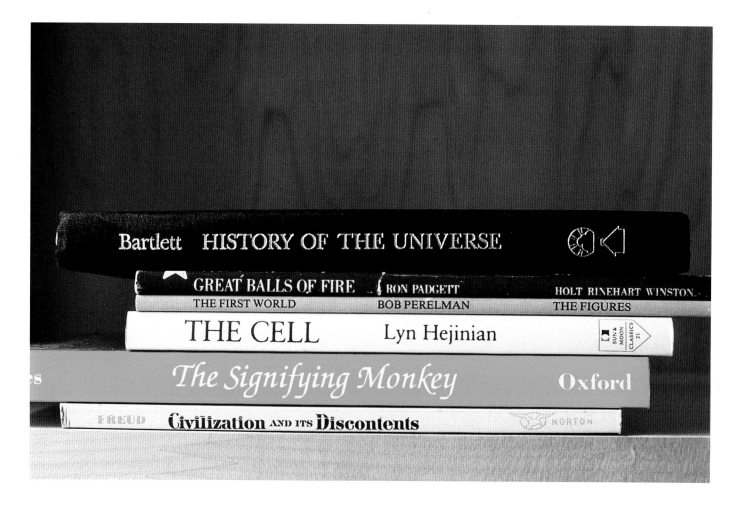

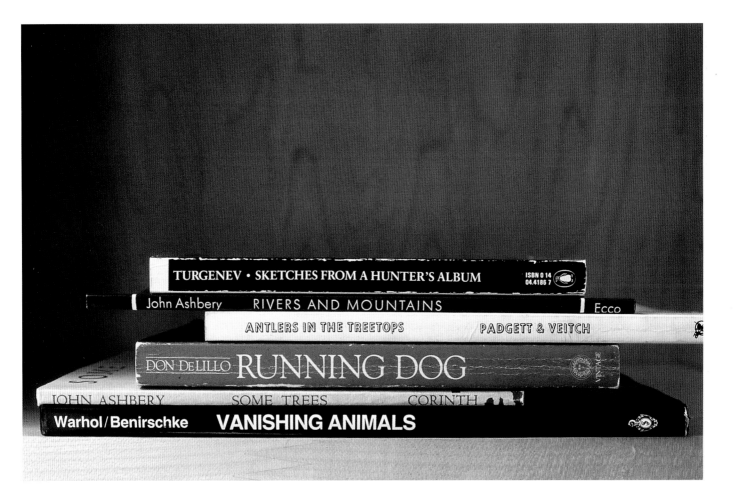

DEFOE

Robinson Crusoe

I Remember

ISBN 0 14
02.4521 9

that they were at the beach Leslie Scalapino

God's Englishman

Hill

BLACK BOY RICHARD WRIGHT

ROUGH TRADES CHARLES BERNSTEIN

Bleeding Optimist
You Bet!
Drawn & Quartered
Happily
For Love

Bleeding Optimist Mary Burger

YOU BET! Ted Greenwald

DRAWN & QUARTERED ROBERT CREELEY &

HAPPILY POST-APOLLO

for LOVE *POEMS*
 1950-1960

A DAY AT THE BEACH ROBERT GRENIER

THE BATHERS LORENZO THOMAS

SHARK 1

SHARK 2

SHARK 3

JONES SUDDEN VIOLENCE

JOHN CAGE SILENCE

BOOKPACE 2002

The home of art patron Linda Pace (1945–2007), founder of the San Antonio art center ArtPace, showcased her extensive collection of contemporary art. Numerous books also filled the house, in both the public and private spaces (including more books, organized on large shelves, than I've ever seen before in a bathroom). Many of the books in the public areas were art catalogs and publications related to the artists in her collection, whereas the books in the private quarters were very personal in nature, dealing with dreams, grieving, and myth, to name a few examples. Combining books from different parts of the house—mixing the public with the private—became the focus of this sorting. When complete, the book clusters were installed upstairs in a private room that had a small library.

Cinderella

Sy Safransky FOUR IN THE MORNING

DEREK &
JULIA PARKER *DREAMING*

STRETCHING AND

Sarton **Recovering** NORTON

HA JIN Waiting VINTAGE

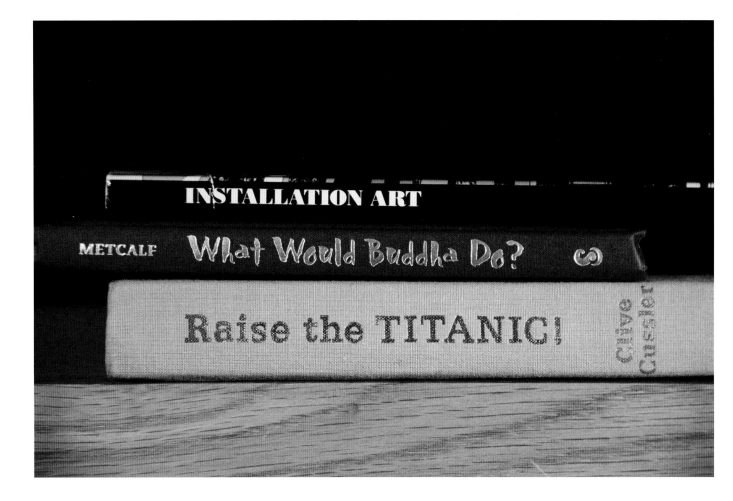

INSTALLATION ART

METCALF — What Would Buddha Do?

Raise the TITANIC! — Clive Cussler

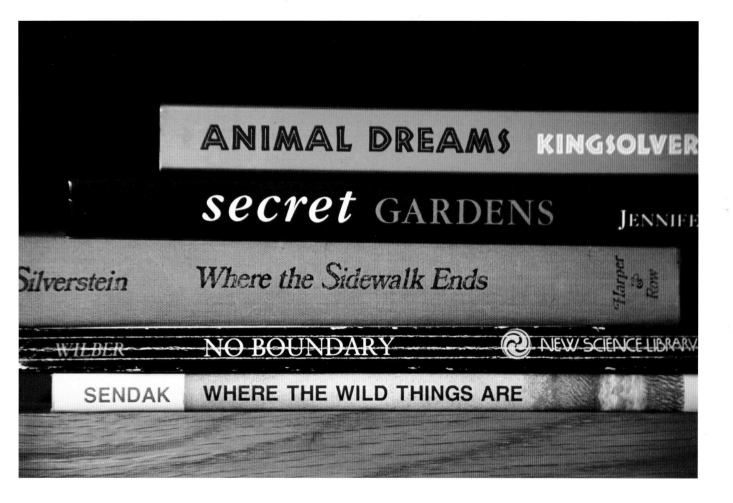

ANIMAL DREAMS KINGSOLVER

secret GARDENS JENNIFE

Silverstein *Where the Sidewalk Ends* Harper & Row

WILBER NO BOUNDARY NEW SCIENCE LIBRARY

SENDAK WHERE THE WILD THINGS ARE

TONI MORRISON PARADISE

GRUMBACH *EXTRA INNINGS* NORTON

UKIE MILLER, PH.D. After Death

with Suzanne Lipsett

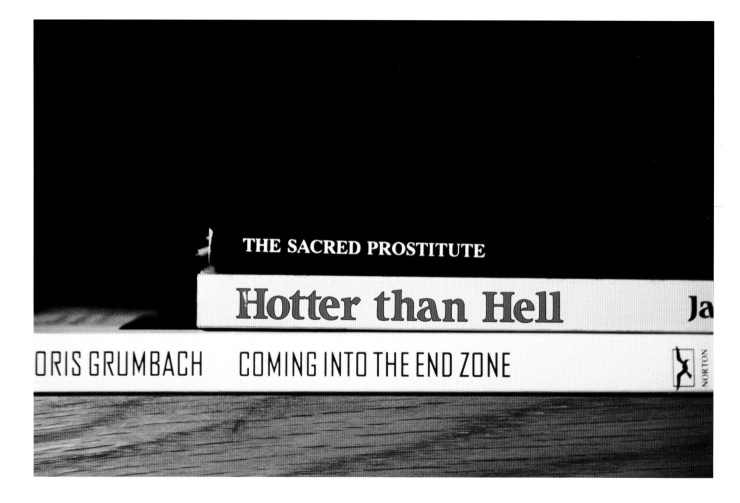

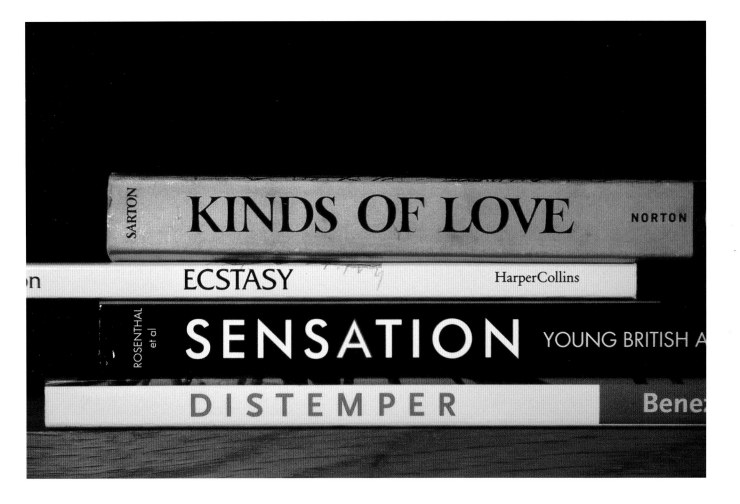

SARTON **KINDS OF LOVE** NORTON

ECSTASY HarperCollins

ROSENTHAL et al **SENSATION** YOUNG BRITISH A

DISTEMPER Bene

SARK inspiration sandwich

Yoko Ono **GRAPEFRUIT** Simon & Schuster

 BEGINNER BOOKS **Green Eggs and Ham**

Sarton *A Grain of Mustard Seed*

 c r e a m

Optimism

LIFE DOESN'T FRIGHTEN ME Stewart, Tabori

Pema WHEN THINGS FALL APART SHA

rsall, Ph.D. SUPERIMMUNITY

That's the Way I See It

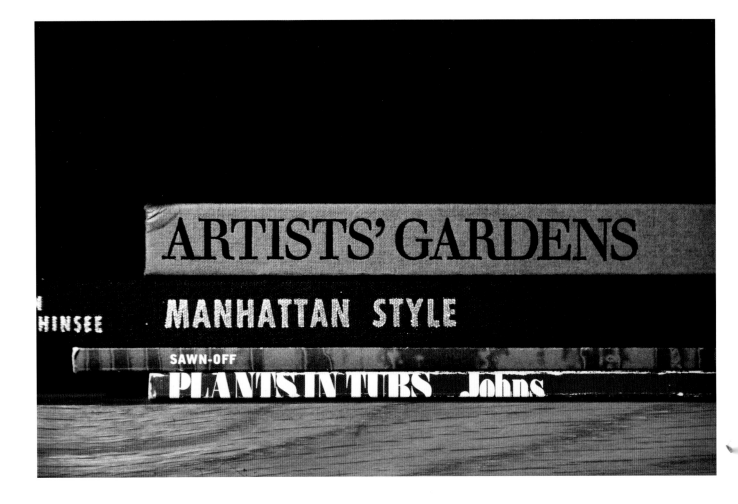

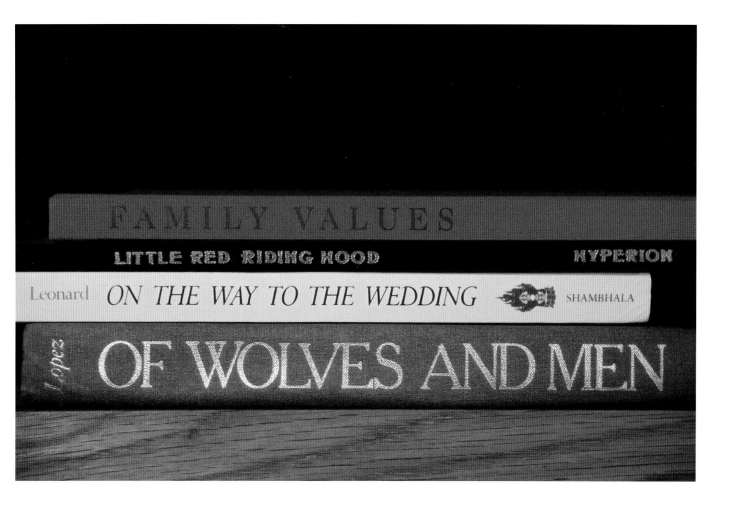

FAMILY VALUES

LITTLE RED RIDING HOOD HYPERION

Leonard *ON THE WAY TO THE WEDDING* SHAMBHALA

Lopez OF WOLVES AND MEN

The Secret Language of DREAMS FONTANA

FENCES & GATES 0-376-01105-X LANE 4

QUEUES, RENDEZVOUS, RIOTS

PICNIC, LIGHTNING PITTSBURGH

SWIMMING POOLS 0-376-01606-X LANE

Stafford **The Way It Is** GRAYWOLF

ONG WALKING IN CIRCLES GEORGE BRAZILLER

Kabat-Zinn ❋ Wherever You Go, There You Are

SORTING
STRINDBERG 2004

While on a residency in Stockholm in 2004, the Strindberg Museum generously gave me permission to work with Strindberg's books. August Strindberg (1849–1912) lived in a fourth-floor apartment, and a room on the sixth floor housed his research library with the majority of his books. Because many of Strindberg's books were extremely fragile, I spent three days taking digital pictures of them and writing the book titles on notecards. Then I worked at home, shuffling the hundreds of notecards to create the clusters and then cross-checking against the digital pictures to make sure the physical properties of the books would work in these combinations. Although I grew up speaking Swedish, this was the first time I sorted books in a language other than English. Working with a famous writer after his death raised new questions: was the goal to write in Strindberg's voice, to somehow channel him through his books? Was I obligated to express his opinions, or was there space for my own? Did the clusters need to reflect topics from his era or mine? The breadth of Strindberg's interests was immense. If nothing else, I wanted my book clusters to do justice to Strindberg's omnivorous intellectual appetite, and I felt happiest when this diversity could be reflected within just a single photograph.

En svensk utopist
Lungsot kan botas
Med hammaren och lyran

A Swedish Utopian
Tuberculosis Can Be Cured
With Hammer and Sickle

Soc. Bibliotek 8. H:son-Holmberg: En Svensk utopist.

HEDVIG LINDHOLM-ENEROTH: LUNGSOT KAN BOTAS.

CARL SAM ÅSBERG: MED HAMMAREN OCH LYRAN.

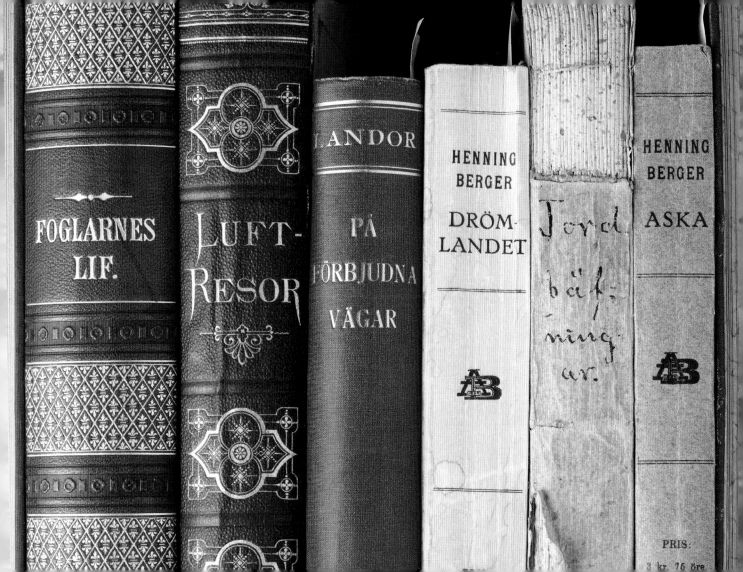

FOGLARNES
LIF.

LUFT-
RESOR

LANDOR

PÅ
FÖRBJUDNA
VÄGAR

HENNING
BERGER

DRÖM-
LANDET

Jord
bäf:
ning:
ar.

HENNING
BERGER

ASKA

PRIS:
3 kr. 75 öre

Misantropen
I öknen
Stjärnhimlen
I ensomhed

The Misanthrope
In the Desert
The Starry Sky
In Solitude

MOLIÈRE: MISANTROPEN. Pris 2 kronor

ALBERT WICKMAN: I ÖKNEN.

SERVISS: STJÄRNHIMLEN

AUG. STRINDBERG: I ENSOMHED

Vildmarkens dotter
Vid altaret
Vildfågeln
Ur en fallen skog

Daughter of the Wilderness
At the Altar
The Wild Bird
From a Fallen Forest

JAMES OLIVER CURWOOD: VILDMARKENS DOTTER

E. WERNER: VID ALTARET

NANNA WALLENSTEEN: VILDFÅGELN 15

Gustav Hedenvind-Eriksson: Ur En Fallen Skog. Pris 1 kr.

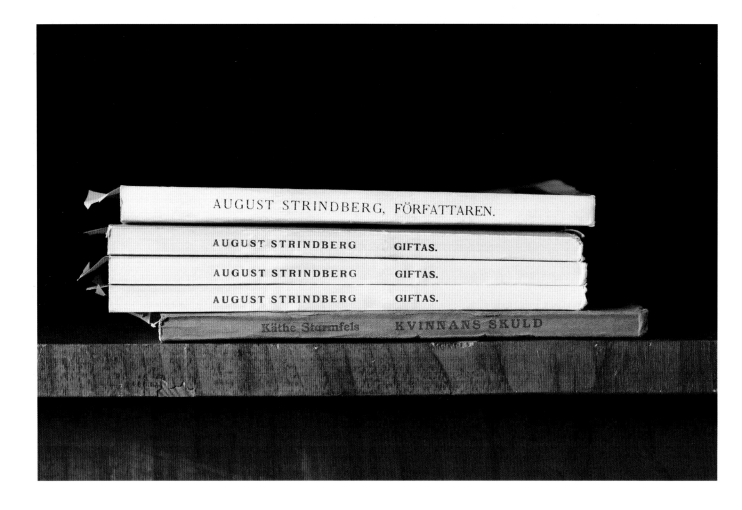

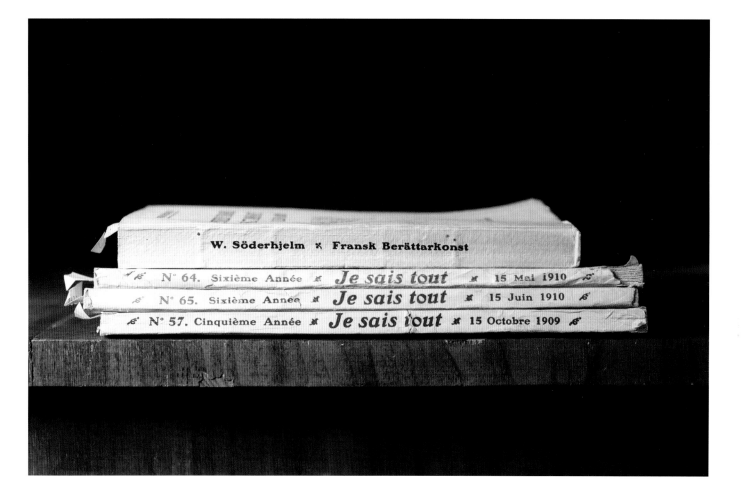

A.E. NORDENSKIÖLD

STUDIER

OCH

FORSKNINGAR

**

GUSTAF KOLTHOFF

·UR·
·DJURENS·
·LIF·

Gabriel
Scott

Sjø-
pape-
gøier

C. AURIVILLIUS

NORDENS

FJÄRILAR

BENGT STRÖM

TIMMERMÄN

OCH

NYCKELPIGOR

PRIS: 5:25

Pierre Lelong

Parasites
du
Quartier
Latin

Prix : 3 fr. 50

VICTOR-FAVARD & Cie
ÉDITEURS

1902

Vårt lif efter döden
Lyset
Lykkelandet
Parasiter

Our Life After Death
The Light
The Land of Happiness
Parasites

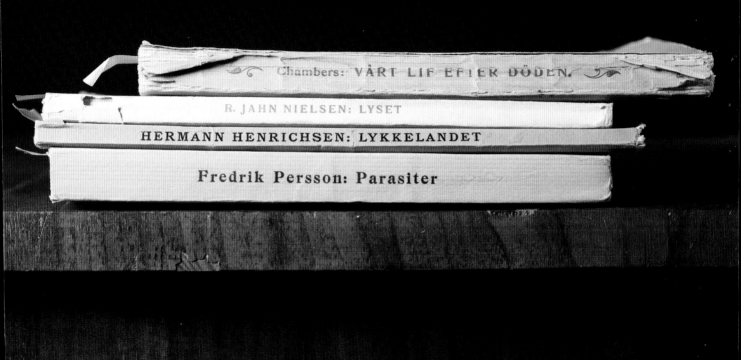

Chambers: VÅRT LIF EFTER DÖDEN.

R. JAHN NIELSEN: LYSET

HERMANN HENRICHSEN: LYKKELANDET

Fredrik Persson: Parasiter

ONCE UPON A TIME IN DELAWARE/ IN QUEST OF THE PERFECT BOOK 2012

In 2010, the Delaware Art Museum invited me to work with the books in the Helen Farr Sloan Library's M. G. Sawyer Collection of Decorative Bindings. The collection comprises over two thousand books, acquired on the basis of their cover design. It was an opportunity to take a close look at the culture and history of the United States betweeen approximately 1870 and 1920. Fiction was dominated by themes of travel, romance, science, the automobile, rural American farm life, and the West. The Old World also hovers around the popular imagination in the many books about knights, kings, and European history. A visual and linguistic shift takes place between prim Victorian bindings and the racy dust jackets of books thirty years later. Spectacularly gilded covers reflect the wealth of the United States during certain periods, and austere designs take over during times of belt-tightening. I noticed a curious surge in late nineteenth-century fiction romanticizing Native Americans and despaired when I realized how this coincided with their violent displacement and decimation.

I came to know the books in this collection intimately through several visits to the museum but also by working remotely with the online database of the book covers. I printed out about seven hundred small-scale copies and spent months arranging them in my studio before coming to the museum to finalize the groupings. This sorting yielded more book clusters than any other I had done to date, but it was an agonizing last day, and it felt impossible to stop when there was always one more book that begged for inclusion. For the first time, I worked with the book covers up, in part because the titles didn't always appear on the spines, but also because the covers were rich with information and so beautiful that I couldn't imagine displaying them otherwise.

If Youth But Knew
The Old Knowledge
At the Time Appointed

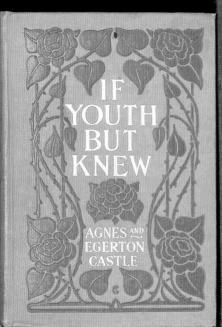

IF
YOUTH
BUT
KNEW

AGNES AND
EGERTON
CASTLE

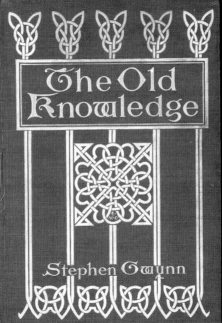

The Old
Knowledge

Stephen Gwynn

At the
Time Appointed
by
A. Maynard Barbour

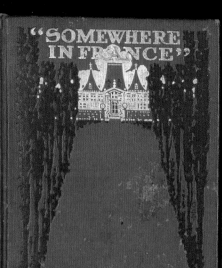

"SOMEWHERE IN FRANCE"

RICHARD·HARDING·DAVIS

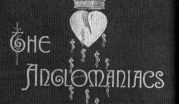

THE ANGLOMANIACS

MEET THE GERMANS

HENRY ALBERT PHILLIPS

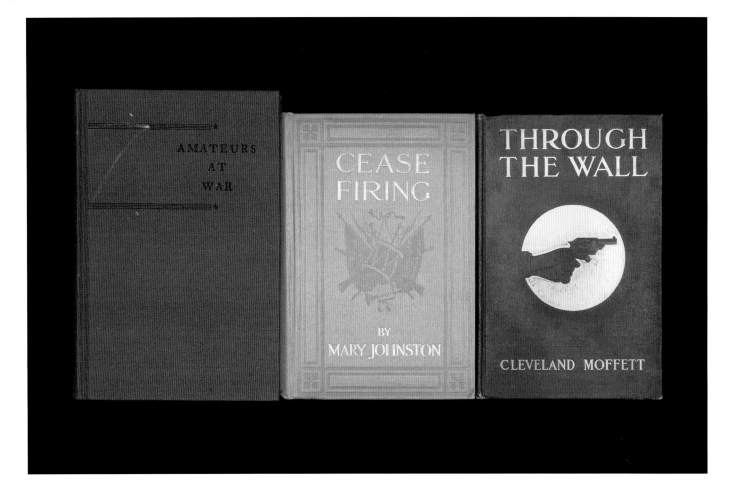

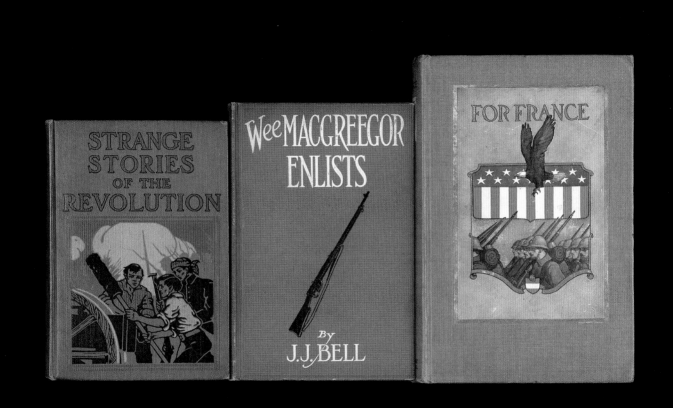

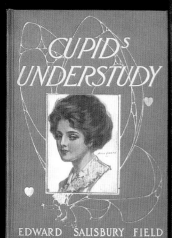

CUPID'S
UNDERSTUDY

EDWARD SALISBURY FIELD

THE SILVER LOVE

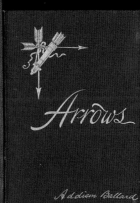

Arrows

Addison Ballard

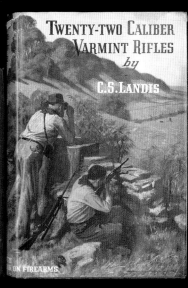

TWENTY-TWO CALIBER
VARMINT RIFLES
by
C. S. LANDIS

A · ON FIREARMS

A Captured Santa Claus
Blindfolded
The Prisoner of Mademoiselle

A CAPTURED
SANTA CLAUS

THOMAS·NELSON·PAGE

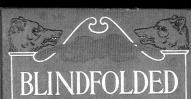

BLINDFOLDED

EARLE ASHLEY WALCOTT

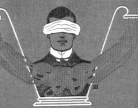

*The Prisoner of
Mademoiselle*

Charles G. D. Roberts

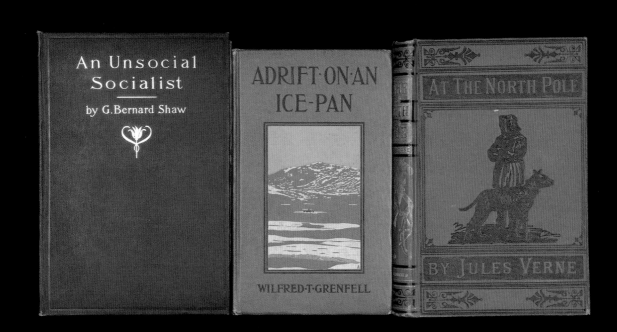

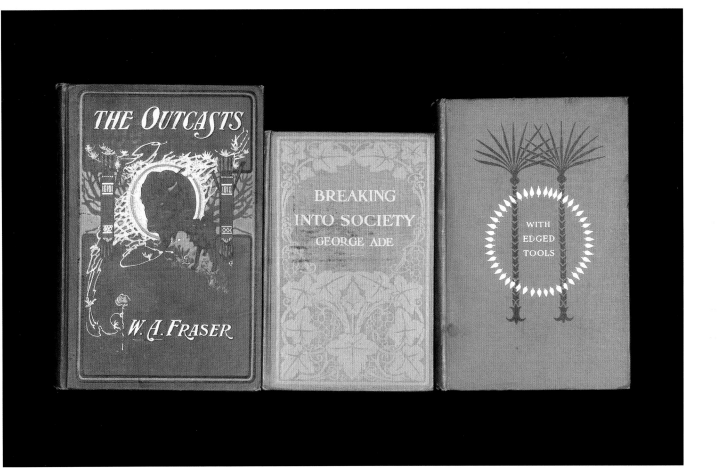

INDIAN HISTORY
FOR YOUNG FOLKS

F. S. DRAKE

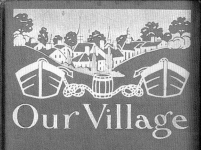

Our Village

Joseph C. Lincoln

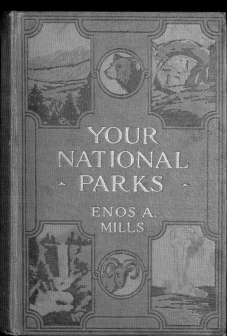

YOUR
NATIONAL
~ PARKS ~

ENOS A.
MILLS

The Spread Eagle
The Giant Scissors
Poor Splendid Wings

The
Spread
Eagle

GOUVERNEUR. MORRIS

THE·GIANT
SCISSORS

ANNIE·FELLOWS·JOHNSTON

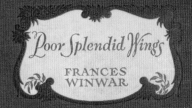

Poor Splendid Wings
FRANCES
WINWAR

The Memoirs
of a Baby

By
Josephine
Daskam

WOMAN
AND
LABOR

OLIVE
SCHREINER

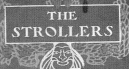

THE
STROLLERS

FREDERIC S.
ISHAM

I RULE
THE HOUSE

EDMUND VANCE COOKE

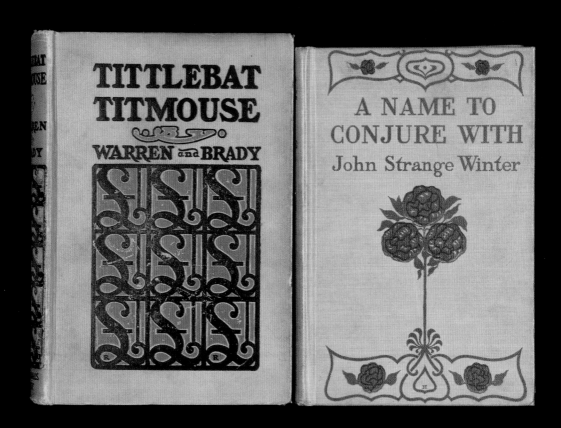

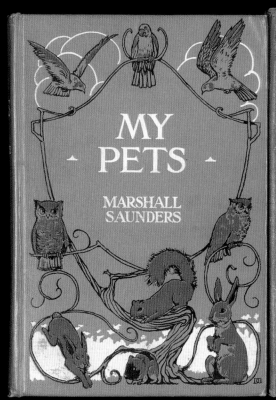

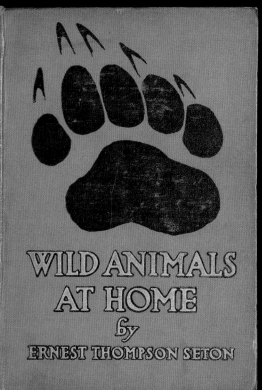

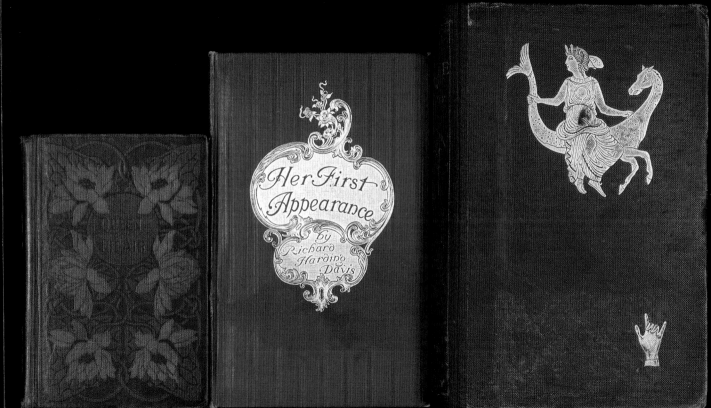

Her First Appearance

*by
Richard
Harding
Davis*

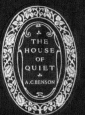

THE
HOUSE
OF
QUIET

A.C.BENSON

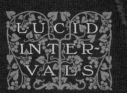

LUCID
INTER-
VALS

The
Inevitable

Philip Verrill Mighels

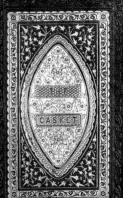

CASKET

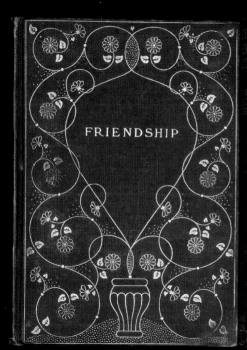

FRIENDSHIP

THE SILENT PLACES

By
STEWART EDWARD WHITE
Author of The Blazed Trail.

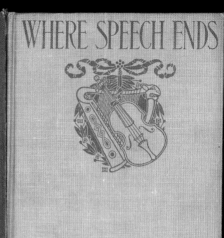

WHERE SPEECH ENDS

ROBERT HAVEN SCHAUFFLER

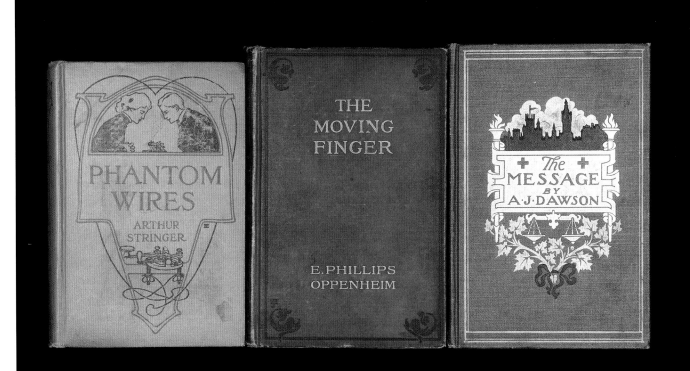

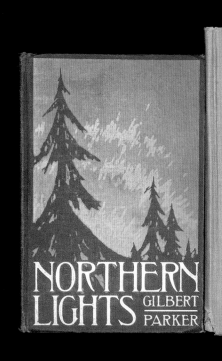

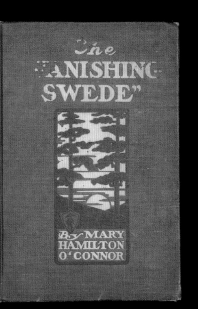

The Gentle Reader

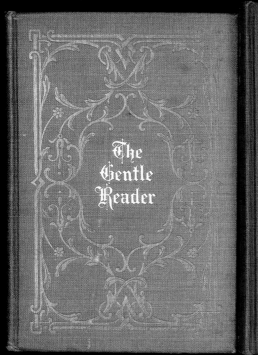

THE
CURVED
BLADES
By
CAROLYN
WELLS

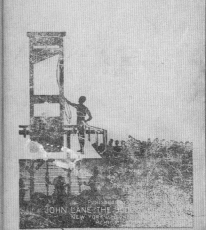

THE LITERARY
GUILLOTINE

Publishers
JOHN LANE THE BODLEY HEAD
NEW YORK

The Lost Word
Drifted In
Uncanonized

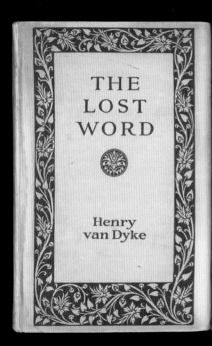

THE
LOST
WORD

Henry
van Dyke

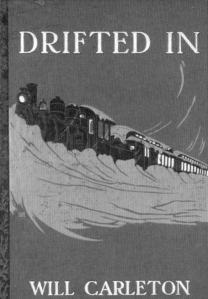

DRIFTED IN

WILL CARLETON

Uncanonized

Margaret Horton Potter

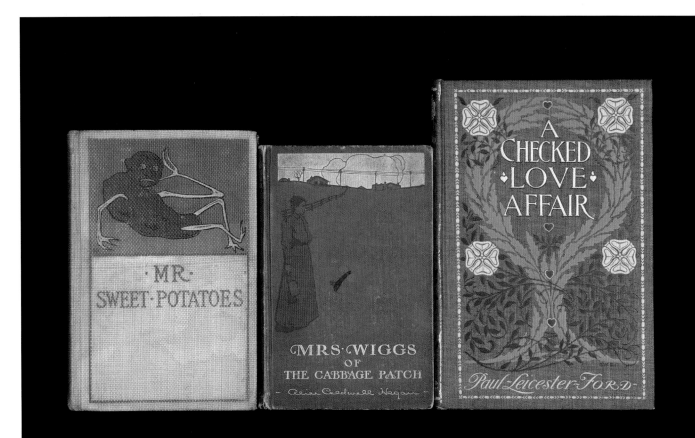

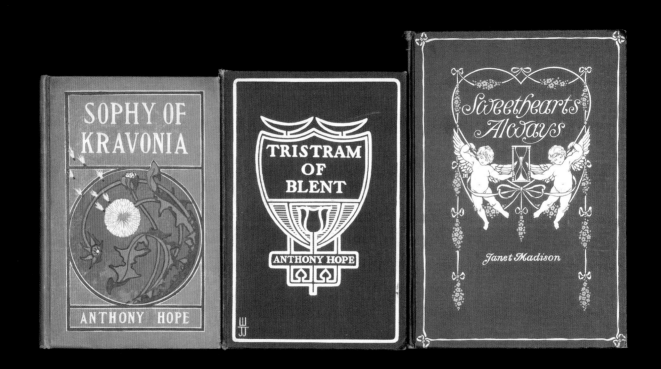

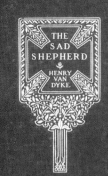

THE SAD
SHEPHERD

HENRY VAN
DYKE

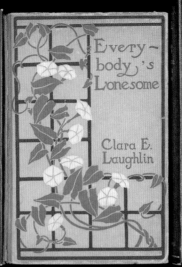

Every~
body's
Lonesome

Clara E.
Laughlin

Rejected of Men

By Howard Pyle

ON OUR HILL

JOSEPHINE DASKAM BACON

Captain Courtesy
An Amiable Charlatan
At Heart a Rake

CAPTAIN
COURTESY

EDWARD CHILDS CARPENTER

AN AMIABLE
CHARLATAN

E. PHILLIPS
OPPENHEIM

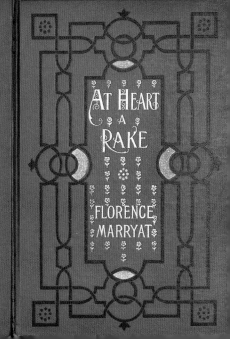

BEHOLD
THE
WEST INDIES

AMY OAKLEY

THE
SANDS OF
PLEASURE

FILSON YOUNG

AN
ISLAND
CABIN

ARTHUR HENRY

Where The
Wind Blows

Katharine Pyle

Hope and Have
The Life that Counts

HOPE
AND HAVE

OLIVER·OPTIC

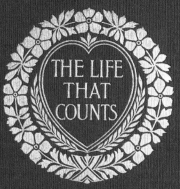

THE LIFE
THAT
COUNTS

SAMUEL·V·COLE

ACKNOWLEDGMENTS

I would like to thank the many individuals and institutions over the past twenty years for the trust and confidence they placed in me by allowing me to work with their books. Enormous thanks to Catharine Clark and the staff at Catharine Clark Gallery for 14 happy years of steadfast support of this project and so many others. Particular thanks to Marianne Landqvist at the Strindberg Museum in Stockholm and Margaret Winslow and Rachael DiEleuterio at the Delaware Art Museum for the opportunity to work with rare and sometimes very fragile book collections. Thanks to the entire team at Chronicle for the generous, collaborative, and positive spirit shown throughout the process of making this book. (Interning at Chronicle was an unrealized dream during several college summers, but it is thrilling that things sometimes work out in the long run.) Finally, my deepest thanks to my friends and family, particularly my parents, Stina and Herant Katchadourian, and my husband, Sina Najafi.

—Nina Katchadourian

"The Lost Word Drifted In Uncanonized"[1]

Acknowledgments can leave me at a loss for words because there are so many people to thank and it is impossible to adequately recognize everyone involved. Getting to a point where words become a book, or where art composed of words becomes the subject of a book, is the work of many.

"The work" in this context is also the body of photographs titled *Sorted Books* by Nina Katchadourian, whose artwork I have had the honor to exhibit and represent since 1999. In that year, the project was titled *Eight Years of Sorting Books*. Two decades into the sortings, Nina's endeavor continues to challenge, delight, and resonate with her viewers—and readers.

We are all indebted to Nion McEvoy, who first suggested that I present the proposal for this publication to Chronicle Books. Once Chronicle embraced the project, the hard work of organizing and editing was artfully managed by Bridget Watson Payne and her team.

Because every book is a collective enterprise, I must acknowledge the essential contributions of my staff, particularly Rhiannon MacFadyen, whose mastery of "the secret language"[2] of computers and digital images enables all the other work to happen more easily and elegantly. Thank you all.

Both artists and their galleries are dependent upon the enlightened patronage of prescient collectors and insightful curators. They support and facilitate the transition of significant bodies of work, such as Nina's, from the private to the public realm. Thank you—you know who you are.

Nina lovingly explores libraries and transforms their contents into poetic portraits with her hand and her camera. The continuation of her work would not have been possible without access to library collections that have welcomed Nina's interventions into their stacks.

Finally, I would like to recognize my sister Emilie Clark, whose library, assembled and shared with her husband Lytle Shaw, was the object of Nina's taxonomic cataloging project titled "Sorting Shark." Emilie, thank you for sharing with me what you first recognized as important work.

—Catharine Clark, July 2012

1 Nina Katchadourian, from "Once Upon a Time in Delaware/In Search of the Perfect Book," *Sorted Books* project, 2012

2 Nina Katchadourian, from "BookPace," *Sorted Books* project, 2002

Copyright © 2013 by Nina Katchadourian.

Essay "Open Stacks" copyright © 2013 by Brian Dillon.

All rights reserved. No part of this book may be reproduced in any form without written permission from the publisher.

Library of Congress Cataloging-in-Publication Data available.

ISBN: 978-1-4521-1329-6

Manufactured in China.

Design by Brooke Johnson

10 9 8 7 6 5 4 3 2 1

Chronicle Books LLC
680 Second Street
San Francisco, CA 94107
www.chroniclebooks.com